Antonin Artaud

The Human Face

and Other Writings

on His Drawings

Translated by
Clayton Eshleman and Stephen Barber

Edited and with an Afterword by
Stephen Barber

Introduction by
Richard Hawkins

T0043325

DIAPHANES

THE HUMAN FACE

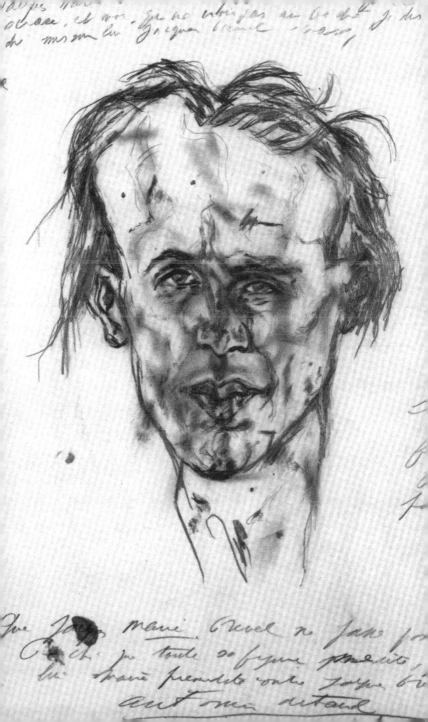

RICHARD HAWKINS

INTRODUCTION

> '*Artaud excavates, rather than draws, beginning in 1945, with the cruelty of a drill that begins by hammering a hole defined by a black line and ends by pulling a face out of it*'.
>
> Julia Kristeva[1]

The visual art of Antonin Artaud begins very late in the poet's life. The stand-alone large format graphite-on-paper drawings that are most widely known appear for the first time in January 1945 and rapidly become extensions of the numerous poems and essays, public performances and radio broadcasts that the poet produced during this period. Always with small school notebooks in his pocket to scribble down ideas and images, Artaud drew nearly uninterrupted until the month before his death in March 1948. The three poems that follow serve as primary introductions, in their author's own voice, of the poet's excursions into visual art.

The drawings of Artaud's that have been preserved can be broken into several relatively distinct categories though a few overlaps and repetitions of motifs occur.

'GRIS-GRIS'

First initiated during Artaud's disastrous journey to Ireland (1937) and picking up again during his first year at the Ville-Évrard psychiatric hospital (1939), these punctured,

burnt and twisted exclamations on paper are modeled on the African gris-gris charms known to ward off evil spirits, cause bad luck or prevent pregnancy. Artaud's gris-gris are dire prophecies and protective spells, scrawled with hermetic signs and mailed to friends and public figures. They alternately manifest as both discrete doses of inoculation and virtual plague-infected rags. After 1939 the poet would lapse into near silence for the next three and a half years.

RODEZ DRAWINGS

Under the supervision of Dr Ferdière at Rodez clinic the poet was subjected to the much-maligned electro-shock therapy that is so often associated with Artaud's legacy. But it's also worth noting that only a few weeks after the last of these treatments the poet completes, in January 1945, the first four of the twenty-five large scale drawings that characterize this body of work.

Understanding the figural content of these drawings has, with a few exceptions,[2] proved quite difficult. Most writers, rather than risking mistranslation, have chosen to maintain their cryptic integrity with inventories of the myriad discordant elements found within them. The earliest of these will stand as representative and is from one of Artaud's closest allies near the end of his life and the eventual editor of his *Œuvres Complètes*, Paule Thévenin:

> '... wheels, suns, often phallic-looking cannons, rifles, sickles, toothed combs, blocks of wood, gallows, envelopes, coffins, telescopes, helmets, unformed cells, mutilated bodies, deprived of one arm or both, sometimes having only a single monstrous leg, but capable of possessing quadruple nipples and trunkless legs, bodiless heads, traces of feet and a multitude of bones...'[3]

In a conversation between Thévenin and Sylvère Lotringer,[4] the two renowned Artaud scholars propose that, in reference to the period in which these drawings were made, an under-emphasized aspect of the work was the poet's sense of humor. Applied to the Rodez drawings a jocular-

ity in intent adds a wry self-awareness to what has generally been seen as striking evidence of just how imprisoned Artaud was within the depths of a savage unconscious.

Yet considering the audience to which the drawings were first shown (or, indeed, primarily addressed), doctors Ferdière and Latrémolière of the Rodez clinic, a fully conscious attitude of sardonic teasing and pestering provocation could theoretically be seen, picture-traps set for foolish doctors to endlessly puzzle over. It only adds emphasis to remember that both psychiatrists were perceived by Artaud as his cultural, social and intellectual inferiors, one a wannabe Surrealist who ordered his electro-shocks, the other a naïve religious nut who administered them.

Exactly coinciding with his release from the Rodez clinic and the cessation of supervision by Dr Ferdière, Artaud makes the last of the drawings in this style in May 1946.

PORTRAITS

These drawings, in their relatively straightforward attempts at naturalistic likeness, have often been seen as the veritable proof of the author's return to the civilized from the clutches of madness. However, in the months leading up to his first portraits in August 1946, Artaud was far from anti-social and incapacitated: he had already overseen the publication of *A Voyage to the Land of the Tarahumara*, coached actors to perform newly written works and recorded a broadcast for French radio. Seeing the portraits as a progression – rather than a redirection or a change of intention – forces the previous set of drawings from Rodez into representing the oppressive and incommunicable maelstrom of mental instability and the portraits as their more suitable, sane, well-adjusted and socially-engaged next step. But to Artaud's mind he had been neither sane nor insane but a genius struggling to be understood by much lesser beings.

In *The Human Face*, specifically written to accompany the public exhibition of Artaud's portraits and the first public showing of the Rodez drawings in July 1947, the

poet doubles-down on the theme of genius-patient versus imbecilic psychiatrist.[5] To the recurring scenarios of Artaud's work, those previous as well as from this period: the human soul pestered by God and the re-virginized incel surrounded by sexual corruption and ever-circling succubi, a new and more virulent strain is taken against clinical diagnosis and the supposedly objective standards by which sanity is judged.

> 'Dr Gachet did not say to Van Gogh that he was there to straighten out his painting (I myself heard from Dr Gaston Ferdière, head physician at the Rodez asylum, that he was there to straighten out my poetry) ...'[6]

For Artaud, the entire profession of psychiatry was vengeful and wrought with malice. To his mind, only one artist before him had dared being genius in the face of the clinically-determined divide between madness and sanity: 'Only van Gogh was able to draw out of a human head a portrait ... His own'. And it had suicided him.

The poet's decision to naturalistically represent resemblance in the portraits is rather out of step given the context of post-war Parisian art. Artaud defends this position in stating '...it's absurd to reproach a painter for being academic who now still persists in reproducing the features of the human face as they are...' and deriding more contemporary alternatives as '...the most specious secrets in which abstract or nonfigurative painting can delight...'.

In other passages, no matter the 'empty force' and 'field of death' the portraitist may see written in the faces of his sitters, Artaud is duty-bound to preserve the integrity of appearance, 'to save it', 'giving its own features back to it'. Important to this is the position of observation, Artaud facing his sitter mimics the face-to-face consultation of psychiatrist-to-patient. The poet insists on witnessing instead of diagnosing from that privileged vantage and endeavors to record rather than prescribe. The objective of Artaud's realism is in its stand against interpretations that lead to abuses of authorial privilege such as he had suffered from

psychiatric determinations and treatment. Artaud resolves to portray solely the sitter's own exterior presentation and, in doing so, crowns himself Anti-Psychiatric.

Leading up to the 1947 exhibition at Galerie Pierre the portraits veer away from likeness and take a new turn toward orgies of heads and visages wracked by decomposition, several reproductions of which follow. The last of these date from February 1948.

SCHOOL NOTEBOOKS

The small notebooks or 'cahiers' that Artaud carried with him from early 1945 and throughout the rest of his life are the most under-appreciated aspect of the poet's drawing practice. A number were included in the Centre Pompidou's 1987 'Antonin Artaud – Dessins' exhibition but have rarely been seen until very recently.[7] There are 406 notebooks in total and these include upwards of 20,000 pages of combined art and writing. Unlike his large-scale drawings, Artaud shielded the notebooks from the eyes of his doctors in particular, presumably because their contents could be used to further diagnose him.

The notebooks juxtapose loosely scribbled writing – some of it glossolalia – with countless drawings of heads, machines, anatomical configurations and the hermetic symbols that populate many of the Rodez drawings. The technique is strikingly different though, where the larger scale drawings were executed with confident determination, the point of the graphite skating across the paper very deliberately with movements that use the muscles of the arm and shoulder as much as the fingers and wrist, the notebook drawings are cramped, sketchy and obsessively over-scored with the blunt end of a pencil. The poet pressed the pencil not just onto but into the paper. In these instances errant outlines are not being corrected as much as more significant lines are being relentlessly and ritualistically emphasized, the page rutting and furrowing under the pressure while the accumulated graphite brightens to take on a silvery reflectivity.

The notebooks were, as Artaud asserts in *Ten years that the language is gone*, 'an efficacious sieve on the materialized paper', filtering mechanisms where the *prima materia* of his drawings, late poems and radio scripts were incubated. They are, however, not sketches but are, as summarized near the end of *50 Drawings to assassinate magic*, '…what used to be called the great alchemical work'. Their very format, deceptively innocuous composition books that, just like the inconspicuous paper envelopes used to send his curses and spells through the mail, seal off and shroud their dangerously divine content from anyone other than their maker and his few initiates. They are Artaud's *vas Hermeticus*, his occult organs of alchemical transubstantiation.

The early curses and spells had continued undercover within the notebooks all along: 'What are they? What do they mean? The innate totem of man. Grigris to come back to man' and 'Purely and simply the reproduction upon paper of a magical gesture'.

NOTES

1 Julia Kristeva, *The Severed Head: Capital Visions*, translated by Jody Gladding (Columbia University Press, 2012), p. 108.

2 Ros Murray's analysis of 'The Sexual Inadequacy of God' and 'The Machine of Being' is of particular interest. Under 'Perverse Incubators' in: *Antonin Artaud: The Scum of the Soul* (Palgrave Macmillan, 2014), pp. 127–134.

3 Paule Thévenin and Jacques Derrida, *Antonin Artaud: Drawings and Portraits* (MIT Press, 1986), p. 29.

4 Sylvère Lotringer, *Mad Like Artaud*, transl. by Joanna Spinks (Univocal, 2015), pp. 200–201.

5 More overt examples of this theme can be found in 'Alienation and Black Magic' in *Artaud the Mômo*, transl. by Clayton Eshleman (Diaphanes, 2020), pp. 88–111 and *Van Gogh the man suicided by society*, transl. by Catherine Petit and Paul Buck (Vauxhall & Company, 2019) completed just four months prior to *The Human Face*.

6 Ibid, *Van Gogh*, p. 18.

7 While not an exhaustive list, of note are 'Antonin Artaud' at MUMOK, Vienna in 2002 and more recently 'Antonin Artaud: Cahiers de Rodez et d'Ivry, 1945–1948' at Cabinet Gallery, London in 2019.

LE VISAGE HUMAIN

THE HUMAN FACE

Le visage humain est une force vide, un champ de mort.
La vieille revendication révolutionnaire d'une
forme qui n'a jamais correspondu à son corps,
qui partait pour être autre chose que le corps.
C'est ainsi qu'il est absurde de reprocher d'être
académique à un peintre qui à l'heure qu'il est
s'obstine encore à reproduire les traits du visage
humain tels qu'ils sont ; car tels qu'ils sont ils
n'ont pas encore trouvé la forme qu'ils indiquent
et désignent ; et font plus que d'esquisser, mais
du matin au soir, et au milieu de dix mille
rêves, pilonnent comme dans le creuset d'une
palpitation passionnelle jamais lassée.
Ce qui veut dire que le visage humain n'a pas encore
trouvé sa face
et que c'est au peintre à la lui donner. Mais ce qui
veut dire que la face humaine telle qu'elle est
se cherche encore avec deux yeux, un nez, une
bouche et les deux cavités auriculaires qui
répondent aux trous des orbites comme les quatre
ouvertures du caveau de la prochaine mort.
Le visage humain porte en effet une espèce de mort
perpétuelle sur son visage
dont c'est au peintre justement à le sauver
en lui rendant ses propres traits.
Depuis mille et mille ans en effet que le visage
humain parle et respire
on a encore comme l'impression qu'il n'a pas encore
commencé à dire ce qu'il est et ce qu'il sait.
Et je ne connais pas un peintre dans l'histoire de
l'art, d'Holbein à Ingres, qui, ce visage d'homme,
soit parvenu à le faire parler. Les portraits
d'Holbein ou d'Ingres sont des murs épais, qui
n'expliquent rien de l'antique architecture
mortelle qui s'arc-boute sous les arcs de voûte
des paupières, ou s'encastre dans le tunnel
cylindrique des deux cavités murales des
oreilles.

The human face is an empty force, a field of death.
The old revolutionary demand for a form which has
never corresponded to its body, which left to be
something other than the body.
So it's absurd to reproach a painter for being
academic who now still persists in reproducing
the features of the human face as they are; for as
they are they still have not found the form that
they indicate and specify; and do more than
sketch, but from morning to night, and in the
midst of ten thousand dreams, pound as in
the crucible of a never-tiring impassioned
palpitation.
Which means that the human face has not yet found
its face,
and that it's up to the painter to give it one. But this
means that the human face as it is is still
searching with two eyes, a nose, a mouth and
two auricular cavities which correspond to the
holes of orbits like the four openings of the burial
vault of approaching death.
The human face bears in fact a kind of perpetual
death on its face
from which it's up to the painter precisely to save it
in giving its own features back to it.
For the thousands and thousands of years in fact
that the human face has been speaking and
breathing
one somehow still has the impression that it has not
yet started to say what it is and what it knows.
And I don't know of any painter in the history of art
from Holbein to Ingres, who, this face of man,
succeeded in making it speak. The portraits by
Holbein or Ingres are thick walls which explain
nothing about the ancient mortal architecture
which buttresses itself under the arcs of the
eyelids' vault, or embeds itself in the cylindrical
tunnel of the two mural cavities of the ears.

Le seul Van Gogh a su tirer d'une tête humaine un
portrait qui soit la fusée explosive du battement
d'un cœur éclaté.

Le sien.

La tête de Van Gogh au chapeau mou rend nulles
et non avenues toutes les tentatives de peintures
abstraites qui pourront être faites depuis lui,
jusqu'à la fin des éternités.

Car ce visage de boucher avide, projeté comme en coup
de canon à la surface la plus extrême de la toile,

et qui tout d'un coup se voit arrêté

par un œil vide,

et retourné vers le dedans,

épuise à fond tous les secrets les plus spécieux du
monde abstrait où la peinture non figurative
peut se complaire,

c'est pourquoi, dans les portraits que j'ai dessinés,

j'ai évité avant tout d'oublier le nez, la bouche, les
yeux, les oreilles ou les cheveux, mais j'ai
cherché à faire dire au visage qui me parlait

le secret

d'une vieille histoire humaine qui a passé comme
morte dans les têtes d'Ingres ou d'Holbein.

J'ai fait venir parfois, à côté des têtes humaines, des
objets, des arbres ou des animaux parce que je
ne suis pas encore sûr des limites auxquelles le
corps du moi humain peut s'arrêter.

J'en ai d'ailleurs définitivement brisé avec l'art,
le style ou le talent dans tous les dessins que
l'on verra ici. Je veux dire que malheur à qui
les considérerait comme des œuvres d'art, des
œuvres de simulation esthétique de la réalité.

Aucun n'est à proprement parler une œuvre.

Tous sont des ébauches, je veux dire des coups de
sonde ou de boutoir donnés dans tous les sens du
hasard, de la possibilité, de la chance, ou de la
destinée.

Only van Gogh was able to draw out of a human
head a portrait which was the explosive rocket
of the beating of a buried heart.

His own.

Van Gogh's head in a soft felt hat renders null
and void all the attempts of abstract paintings
which can be made after him, until the end of
eternities.

For this face of an avid butcher, projected like
cannon shot onto the most extreme surface
of the canvas,

and which all of a sudden sees itself stopped

by an empty eye

and returned toward the inside,

completely exhausts the most specious secrets in
which abstract or nonfigurative painting can
delight,

which is why, in the portraits I have drawn,

I have above all avoided forgetting the nose, the
mouth, the eyes, the ears or the hair, but I've tried
to make this face that was speaking to me tell

the secret

of an old human story which passed as if dead in
the heads of Ingres or Holbein.

Sometimes, next to human heads, I've made objects,
trees or animals appear because I'm still not sure
of the limits at which the body of the human
self can stop.

Moreover I've definitely broken with art, style or
talent in all the drawings that you will see here.
I want to say that there will be hell to pay for
whoever considers them works of art, works of
aesthetic simulation of reality.

Not one is properly speaking a work.

All are sketches, I mean soundings or staggering
blows in all directions of chance, possibility,
luck, or destiny.

Je n'ai pas cherché à y soigner mes traits ou mes effets, mais à y manifester des sortes de vérités linéaires patentes qui vaillent aussi bien par les mots, les phrases écrites, que le graphisme et la perspective des traits.

C'est ainsi que plusieurs dessins sont des mélanges de poèmes et de portraits, d'interjections écrites et d'évocations plastiques d'éléments, de matériaux, de personnages, d'hommes ou d'animaux.

C'est ainsi qu'il faut accepter ces dessins dans la barbarie et le désordre de leur graphisme « qui ne s'est jamais préoccupé de l'art » mais de la sincérité et de la spontanéité du trait.

I have not sought to refine my lines or my results,
but to express certain kinds of patent linear truths
which have as much value thanks to words,
written phrases, as graphic style and the
perspective of features.
It is thus that several drawings are mixtures of
poems and portraits, of written interjections
and plastic evocations of elements, of materials,
of personages, of men or animals.
It is in that way that one must accept these draw-
ings in the barbarism and the disorder of their
graphic style "which is never preoccupied with
art" but with the sincerity and spontaneity of
the line.

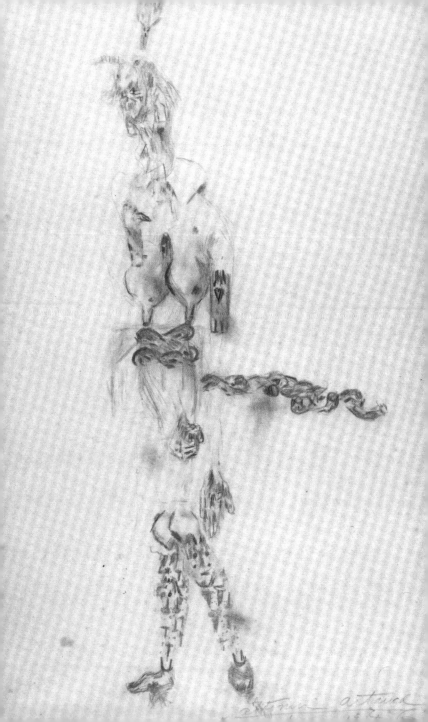

DIX ANS
QUE LE LANGAGE
EST PARTI

TEN YEARS
THAT THE LANGUAGE
IS GONE

Dix ans que le langage est parti,
qu'il est entré à la place
ce tonnerre atmosphérique,
 cette foudre,
devant la pressuration aristocratique des êtres,
de tous les êtres nobles
 du cu,
con, de la pine
de la lingouette
de la plalouettee
 plaloulette
 pactoulette,
de la transe tégumentaire,
de la pelliculle,
nobles raciaux de l'érotique corporelle,
contre moi, simple puceau du corps,
dix ans que j'ai fait sauter une fois de plus le Moyen
 Âge,
avec ses nobles, ses juges, son guet,
 ses prêtres surtout,
 ses églises,
 ses cathédrales,
 ses curés,
 ses hosties blanches.
Comment?
Par un coup
 anti-logique,
 anti-philosophique,
 anti-intellectuel,
 anti-*dialectique*
 de la langue
par mon crayon noir appuyée
 et c'est tout.

Ce qui veut dire que moi le fou et le mômo,
maintenu 9 ans en asile d'aliénés pour passes d'exor-
 cisme et de magie et parce que soi-disant je
 m'imaginais avoir trouvé une magie et c'est fou,
il faut croire que c'était vrai,

Ten years that the language is gone,
that there has entered in its place
this atmospheric thunder,
 this lightning,
facing the aristocratic pressuration of beings,
of all the noble beings
 of the butt,
cunt, of the prick,
of the lingouette,
of the plalouette
 plaloulette
 pactoulcttc,
of the tegumentary trance,
of the pellicle,
racial nobles of the corporeal erotic,
against me, simple virgin of the body,
ten years that I once again blew up the Middle Ages,
with its priests, its judges, its lookout,
 its priests above all,
 its churches,
 its cathedrals,
 its vicars,
 its white wafers.
How?
With an
 anti-logical
 anti-philosophical,
 anti-intellectual,
 anti-*dialectical*
 blow of the tongue
with my black pencil pressed down
 and that's it.

Which means that I the madman and the momo,
kept 9 years in a lunatic asylum for exorcistical
 and magical passes and because I supposedly
 imagined that I'd found a magic and that it
 was crazy,
one must believe it was true,

puisque pas un jour pendant mes 3 ans d'interne-
 ment à Rodez, Aveyron, le Dr Ferdière n'a man-
 qué à 10 heures 1/2 du matin, heure de la visite,
 de venir me dire,
Mr Artaud, tout ce que vous voudrez, mais la Société
 ne peut pas accepter, et je suis ici le représentant
 de la Société.
Si j'étais fou dans mes passes magiques, qu'impor-
 tait donc à la Société qui ne pouvait se sentir ni
 atteinte ni lésée et n'avait qu'à me mépriser et
 me négliger.
Or le Dr Ferdière se présentant en défenseur d'icelle et
 chargé de la défendre devait avoir reconnu de mes
 soi-disant passes soi-disant magiques puisqu'il
 m'opposait la Société,
je dis donc que le langage écarté c'est une foudre que
 je faisais venir maintenant dans le fait humain
 de respirer, laquelle mes coups de crayon sur le
 papier sanctionnent.
Et depuis un certain jour d'octobre 1939 je n'ai
 jamais plus écrit sans non plus dessiner.
Or ce que je dessine
ce ne sont plus des thèmes d'Art
transposés de l'imagination sur le papier, ce ne sont
 pas des figures affectives,
ce sont des gestes, un verbe, une grammaire, une
 arithmétique, une Kabbale entière et qui chie à
 l'autre, qui chie sur l'autre,
aucun dessin fait sur le papier n'est un dessin,
 la réintégration d'une sensibilité égarée,
c'est une machine qui a souffle,
ce fut d'abord une machine qui en même temps a
 souffle.
C'est la recherche d'un monde perdu
et que nulle langue humaine n'intègre
et dont l'image sur le papier n'est plus même lui
 qu'un décalque, une sorte de copie
 amoindrie.

since not a single day during my 3 year internment
at Rodez, Aveyron, did the Dr Ferdière fail at
10:30 AM, the visiting hour, to come and tell
me:
Mr. Artaud, as much as you may wish, Society
cannot accept, and I am here the representative
of Society.
If I was mad in my magical passes, what did it mat-
ter to Society which could not feel attacked or
injured and had only to despise and neglect me.
But the Dr. Ferdière presenting himself as a defender
of that Society and entrusted to defend it must
have recognized my so-called magical so-called
passes since he was opposing me with Society,
I therefore say that the dismissed language is a
lightning bolt that I was bringing forth now in
the human act of breathing, which my pencil
strokes on paper sanction.
And since a certain day in October 1939 I have not
written anymore without drawing anymore
either.
But what I draw
are no longer subjects from Art transposed from
imagination to paper, they are not affective
figures,
they are gestures, a verb, a grammar, an arithmetic,
a whole Kabala, and one that shits to the other,
one that shits on the other,
no drawing done on paper is a drawing, the
reintegration of a strayed sensibility,
it is a machine which has breath,
it was first a machine which at the same time has
breath.
It is a search for a lost world
and one that no human tongue integrates
and the image of which on paper is no more than a
tracing, a sort of diminished
copy.

Car le vrai travail est dans les nuées.
Mots, non,
plaques arides d'un souffle qui donna son plein
mais là où seul le Dernier Jugement pourra
 départager les valeurs,
les *évidences*,
quant au texte,
dans le sang mué de quelle marée
en pourrai-je faire entendre
la corrosive structure,
je dis entendre la constructive structure,
là où le dessin
point par point
n'est que la restitution d'un forage,
de l'avance d'une perforeuse dans les bas-fonds
 du corps sempiternel latent.
Mais quelle logomachie, n'est-ce pas,
ne pourriez-vous, Mr Artaud, éclairer un peu plus
 votre lanterne.
Ma lanterne?
Je dis
Que voilà dix ans qu'avec mon souffle
je souffle des formes dures,
 compactes,
 opaques,
 effrénées,
 sans voussures
dans les limbes de mon corps non fait
et qui de ce fait se trouve fait
et que je trouve chaque fois les 10 000 êtres pour me
 critiquer,
pour obturer la tentative de l'orée d'un infini percé.

Tels sont en tout cas les dessins dont je constelle mes
 cahiers.

En tout cas
la pute,
oh la pute,

For the real work is in the clouds
Words, no,
arid patches of breath which gives its full
but there where only the Last Judgement will be
 able to decide between values,
the *evidences*,
as far as the text is concerned,
in the moulted blood of what tide
will I be able to make heard
the corrosive structure,
there where the drawing
point by point
is only the restitution of a drilling,
of the advance of a drill in the underworld
 of the sempiternal latin body
But what a logomachy, no?
Couldn't you light up your lantern a bit more,
 Mr. Artaud
My lantern?
I say
that look ten years with my breath
I've been breathing hard forms,
 compact,
 opaque,
 unbridled,
 without archings
in the limbo of my body not made
and which finds itself hence made
and that I find every time the 10,000 beings to
 criticize me,
to obturate the attempt of the edge of a pierced
 infinite.

Such are in any case the drawings with which I
 constellate all my notebooks.

In any case
the whore,
oh the whore,

ce n'est pas de ce côté du monde,
ce n'est pas dans ce geste du monde,
ce n'est pas dans un geste de ce monde-ci
que je dis
que je veux et peux indiquer ce que je pense,
et on le verra,
on le sentira,
on s'en rendra compte,
par mes dessins maladroits,
mais si retors,
et si adroits,
qui disent MERDE à ce monde-ci.

Que sont-ils?
Que signifient-ils?

Le totem inné de l'homme.

Les gris-gris pour en revenir à l'homme.

Tous souffles dans l'arcature creuse,
 cave,
 pesti-férante
de mes dents vraies.

Pas un qui ne soit un souffle jeté
 de toute la force
de mes poumons,
de tout le crible
de ma respiration,

pas un qui ne réponde à une activité
 physiologique réelle,
qui n'en soit,
non pas la traduction figurative
mais quelque chose comme le crible efficace,
sur un papier *matérialisé*.

Je suis, paraît-il, *un écrivain*.

it's not from this side of the world,
it's not in this gesture of the world,
it's not in a gesture of this very world
that I say
that I want and can indicate what I think,
and they will see it,
they will feel it,
they will take notice of it
through my clumsy drawings.
but so wily,
and so adroit,
which say SHIT to this very world.

What are they?
What do they mean?

The innate totem of man.

Grigris to come back to man.

All breaths in the hollow, sunken
	pesti-fering
	arcature
of my true teeth.

Not one which is not a breath thrown with all the
	strength
of my lungs
with all the sieve
of my respiration,

not one which does not respond to a real
	physiological activity,
which is not,
not its figurative translation
but something like an efficacious sieve,
on the *materialized* paper.

I am, it seems, *a writer.*

Mais est-ce que j'écris?
Je fais des phrases.
Sans sujet, verbe, attribut ou complément.
J'ai appris des mots, ils m'ont appris des choses.
À mon tour de leur apprendre une manière de
 nouveau comportement.
Que le pommeau de ta tuve patin
t'entrumêne une bivilt ani rouge,
au lumestin du cadastre utrin.
Cela veut dire peut-être que l'utérus de la femme
 tourne au rouge, quand le Van Gogh le fou
 protestataire de l'homme se mêle de trouver leur
 marche aux astres d'un trop superbe destin.
Et ça veut dire qu'il est temps pour un écrivain de
 fermer boutique, et de quitter la lettre écrite
 pour la lettre.

But am I writing?
I make sentences.
Without subject, verb, attribute or complement.
I have learned words, they taught me things.
In my turn I teach them a manner of new behavior.
May the pommel of your tuve patten
entrumene you a red ani bivilt,
at the lumestin of the utrin cadastre.
This means that maybe the woman's uterus turns
 red, when Van Gogh the mad protester
 of man dabbles with finding their march for
 the heavenly bodies of a too superb destiny.
And it means that it is time for a writer to close
 shop, and to leave the written letter
 for the letter.

30 dessins

pour

Abasi pa

la

magie le

ci siut le esc te

50 DESSINS POUR

ASSASSINER LA MAGIE

50 Drawings to Assassinate Magic

Il ne s'agit pas ici de
dessins
 au propre sens du terme,
d'une incorporation quelconque
de la réalité par le dessin.
Ils ne sont pas une tentative
pour renouveler
l'art
auquel je n'ai jamais cru
du dessin
non
mais pour les comprendre
il faut les situer d'abord.
Ce sont 50 dessins
pris à des cahiers
de notes
 littéraires,
 poétiques
 psychologiques,
 physiologiques
 magiques
magiques surtout
magiques d'abord
et par-dessus tout.
Ils sont donc entremêlés
à des pages,
couchés sur des pages
où l'écriture
tient le 1er plan de
la vision,
l'écriture,
la note fiévreuse,
effervescente,
ardente
 le blasphème
 l'imprécation.
D'imprécation en
imprécation
ces pages

Here, it's not a matter of
drawings
 in the strict sense of the word
of some kind of incorporation
of reality through the drawing.
They are not an experiment
aiming at renewing
the art
– which I never believed in anyway –
of drawing
no
but in order to understand them
first you have to be clear about them
These are 50 drawings
taken from notebooks of
 literary,
 poetic
 psychological,
 physiological
 magical
 notes
magical especially
magical first of all
and above all
They are, then, interwoven
with the pages,
embedded upon the pages
where the writing
holds pre-eminence for
vision,
writing
feverish noting,
effervescent,
burning
 blasphemy
 cursing.
From curse towards
curse
these pages

avancent
et comme des corps de
sensibilité
nouveaux
ces dessins
sont là
qui les commentent,
 les aèrent
 et les éclairent
Ce ne sont pas des dessins
ils ne figurent rien,
ne défigurent rien,
ne sont pas là pour
construire
édifier
instituer
un monde
même abstrait.
Ce sont des notes,
des mots,
des trumeaux,
car ardents,
 corrosifs,
 incisifs
 jaillis
 de je ne sais quel
 tourbillon
 de vitriol
sous maxillaire,
sous spatulaire,
ils sont là comme
cloués
et destinés à ne
plus bouger.
Trumeaux donc
mais qui feront
leur apocalypse
car ils en ont trop
dit pour naître

advance
and as bodies with
a new
sensibility
these drawings
are there
to comment on them
 to give them air
 and to illuminate them
These are not drawings
they figure nothing,
disfigure nothing,
are not there in order to
construct
build up
institute
a world
even an abstract one
They are notes,
words,
supporting pillars,
because they're burning,
 corrosive
 incisive
 spurted out
 from some kind of
 whirlwind
 of vitriol
under the jaw
under the blade
they are there as though
nailed down
and destined not to
move any further
so, supporting pillars
but which are going to generate
their own apocalypse
because they've said too much
to be born

et trop dit en naissant
pour ne pas renaître
et prendre corps
alors authentiquement.

Mais tout ceci
ne serait rien
si l'on devait
s'en tenir là,
ne pas sortir
de la page
écrite
puis illustrée
par la lumière
comme vacillante
de ces dessins
qui ne veulent rien dire
et ne représentent
absolument rien.

Pour comprendre ces dessins
intégralement
 il faut
 1° sortir de la page écrite
 pour entrer dans
 le réel
 mais
 2° sortir du réel
 pour entrer
 dans le surréel,
 l'extra-réel,
 le surnaturel
 le suprasensible
 où ces dessins
 ne cessent
 de plonger
parce qu'ils en viennent
et qu'ils ne sont en fait
que le commentaire

and too much in being born
not to be reborn
and to take on their body
authentically then

But all of that,
would be nothing
if you had to
just leave it there,
and not get out of
the written
page
subsequently illustrated
by the light
of these drawings
that is somehow flickering
which intends to say nothing
and represents
absolutely nothing

In order to understand these drawings
in their entirety
 you have to
 1. get out of the written page
 to enter into
 the real
 but
 2. get out of the real
 to enter into
 the surreal,
 the extra-real
 the beyond-the-real
 the beyond-the-perceptible
 that's what these drawings
 never cease
 to plunge into
because that's where they emerged from,
and to understand that, in fact, they are nothing
but the commentary

d'une action qui
a eu réellement
lieu,
que la figuration
sur le papier
circonscrite
d'un élan
qui a eu lieu
et a produit
magnétiquement et
magiquement ses
effets,
et parce qu'ils ne sont
pas ces dessins la
représentation
ou la
figuration
d'un objet
d'un état de
tête ou des yeux,
d'un élément
et d'un événement
psychologique,
ils sont purement
et simplement la
reproduction sur le
papier
d'un geste
magique
que j'ai exercé
dans l'espace vrai
avec le souffle de mes
poumons
et mes mains,
avec ma tête
et mes 2 pieds
avec mon tronc et mes
artères etc, —

of an action which
has really
taken place,
and which the figuration
upon paper
delineates
with a surge
which has taken place
and has generated
its effects
magnetically and
magically,
and because these are
not drawings, the
representation
or the
figuration
of an object
of a state of
the head or the eye
of an element
and of a psychological
event,
they are purely
and simply the
reproduction upon the
paper,
of a magical
gesture
which I've exerted
into the true space
with the breath of my
lungs
and my hands,
with my head
and my 2 feet
with my torso and my
arteries etc, –

Quand j'écris,
j'écris en général
une note d'un
trait
mais cela ne
me suffit pas,
et je cherche à prolonger
l'action de ce que
j'ai écrit dans
l'atmosphère, alors
je me lève
je cherche
 des consonances,
 des adéquations
 de sons,
des balancements du corps
et des membres
qui fassent acte,
qui appellent
les espaces ambiants
à se soulever
et à parler
puis je me rapproche
de la page
écrite
et
 ...
mais j'oubliais de
dire que ces
consonances
ont un sens,
je souffle, je chante,
je module
mais pas au hasard
 non
j'ai toujours
comme un objet prodigieux
ou un monde
à créer et à appeler.

When I write,
in general
I write my notes
just at one stroke
but that's
not enough for me,
and I seek to prolong
the action of what
I've written in
the atmosphere, so then
I get to work
I search out
consistencies,
matches
with the sounds,
with the oscillations of the body
and of the limbs
which will create an action,
which will call upon
the surrounding spaces
to rise up
and to speak
then I get close
to the written
page
and

 ...
but I've been forgetting to
say that those
consistencies
have their meaning,
I breathe out, I sing out,
I make variations
but not just by chance
 no
I always possess
a kind of prodigious subject
or a world
to create and call up

Or je connais
la valeur plastique
objective du souffle,
le souffle c'est quelque
chose dans l'air
ce n'est pas de l'air
 remué
 seulement,
c'est une concrétisation
massive dans
l'air
et qui doit
être sentie
dans le corps et
par le corps
comme une agglomération
en somme atomique
d'éléments
et de membres
qui à ce moment-là
font tableau.
Une matière
très au delà
de celle du sucre
d'orge
naît à ce moment
là
instantanément
dans le corps,

matière électri-
que
qui pourrait
expliquer
si elle était
elle même
explicable
la nature

yes, I know
the creative
objective value of the breath,
the breath that is some-
thing in the air
 it's not
 only
air that that has been
stirred up
it's an immense concretising
in the
air
and which has
to be felt
within the body and
through the body
as with a great amassing
that is, in itself, atomic
of elements
and of limbs
which right at that moment
makes up the drawing.
A substance
very far beyond
that of barley-
sugar
and born right in that moment
there
instantaneously
within the body,

electri-
cal matter
which would be able
to explain
– if it was
itself
explicable –

de certains gaz
atomiques
de certains
atomes répulsifs,
je dis atomes
comme je dirai
pan de mur,
paroi volcanique,
artère en fusion d'un
volcan,
muraille de lave en
marche vers un
renversement de
l'immédiat devenir,

mes dessins donc reproduisent
 ces formes
 ainsi apparues,
 ces mondes de
 prodiges,
 ces objets
 où la Voie
 est faite
 et ce qu'on
appelait le Grand Œuvre
alchimique désormais
pulvérisé car nous ne
sommes plus dans
la chimie
mais dans
la nature
et je crois bien
que la
nature
va parler

Antonin Artaud
31 janvier 1948

the nature
of certain atomic
gases
of certain
atoms in a state of repulsion
I'm talking about atoms now
just as I can say
a section of a wall,
a volcano's interior surface,
the molten artery of a
volcano,
a great wall of lava in
movement towards an
upending of
what will become the immediate,

so, my drawings reproduce
 these forms
 that are made apparent by them,
 these worlds of
 prodigies,
 these objects
 by which the Way
 is established
 and what used to be
called the great alchemical work
is from now onwards
pulverised, because we
are no longer involved in
chemistry
but instead in
nature
and I really believe
that
nature itself
is going to speak out

Antonin Artaud
31 January 1948

STEPHEN BARBER

THE HUMAN FACE:
NOTE ON THE THREE
TEXTS

The Human Face was written in June 1947 to form the text for the catalogue accompanying Antonin Artaud's only exhibition of his drawings held during his lifetime, from 4–20 July 1947 at the art dealer Pierre Loeb's 'Galerie Pierre' in the rue des Beaux Arts, Paris. The small-format catalogue (or brochure) actually held only the text, with no reproductions of Artaud's drawings, because of financial constraints; surviving copies of the publication indicate that it was cheaply printed to a low standard.

Artaud's friend Paule Thévenin told me that the exhibition appeared to her to have been chaotically organised; several of the drawings Artaud selected for the exhibition went missing before the exhibition's span, while they were being framed, and others went missing after the exhibition had ended, while they were waiting to be returned to Artaud's pavilion in Ivry-sur-Seine or to their owners. Paule Thévenin was angry with Loeb for what she perceived as his negligence in allowing the drawings to be stolen or misplaced, though she noted that Artaud himself appeared unconcerned about their loss. Those lost drawings have never been seen in public since.

Artaud had deliberated for several weeks, prior to the exhibition, on which drawings he preferred to show at the Galerie Pierre exhibition. In the notebooks he used on a daily basis for drawings, drafts of his texts, lists and other writings, he noted down numerous lists of drawings, entirely composed of the facial portraits he had executed of friends since his release from the asylum of Rodez in May of the previous year, and disregarding the drawings of fragmented, imaginary figures he had drawn at Rodez in 1945–46. The Galerie Pierre retained no documentation of the exhibition, but memories of Artaud's friends indicated that several notebook lists he compiled in June 1947 give the most accurate account of the twenty to twenty-five drawings that were exhibited.

During the span of the exhibition, Artaud undertook two reading events of new texts, on 4 and 18 July, both Fridays, together with friends such as Colette Thomas, Marthe Robert and Roger Blin. The gallery space was packed and stifling for both events, which took place in the hottest month ever recorded for Paris up to that time (attendees remembered the extreme thundery heat especially of the first event); those two events were Artaud's last public performances prior to his death in March of the following year. For the second event, Artaud read his new text *The theatre and science*, which was published the following year in issue 13 of the arts journal edited by the publisher Marc Barbezat, 'L'Arbalète'. The audience were apparently awestruck by Artaud's reading, but Artaud himself was dissatisfied with his performance. After the reading, he added a note to his text's manuscript: 'This reading took place this evening, Friday 18 July 1947, and by moments it was as though I skimmed the opening of my heart's tone./I would have had to shit blood through my navel to arrive at what I want./For example, three quarters of an hour's beating with a poker on the same spot…'.

The Human Face was translated by Clayton Eshleman from its publication in the journal 'L'Arbalète'.

Ten years that the language is gone... was written in April 1947, in one of Artaud's notebooks. It interrogates his drawing process in its oscillation from drawings executed in his notebooks alongside texts, to those larger-format drawings which held an autonomous status. Artaud did not publish the text in his lifetime, and it was not connected to any planned book or exhibition. It was first published in the journal 'Luna Park' in 1979, then in the catalogue of the first comprehensive exhibition of Artaud's drawings, held at the Centre Georges Pompidou in Paris in 1987, at which a number of Artaud's notebooks were also exhibited for the first time.

Ten years that the language is gone... was translated by Clayton Eshleman from the Centre Georges Pompidou catalogue.

50 Drawings to assassinate magic, Artaud's last major text on his own drawings, was written in one of his notebooks on 31 January 1948, in one writing session. It solely concerns the pencil drawings which he incorporated into his notebooks, image against text, text against image. It is the residue of an unrealized book project proposed to Artaud in the last months of his life by Pierre Loeb; prior to his death, Artaud chose the notebooks from which he intended to extract the fifty drawings to be incorporated into the book, but not the particular drawings themselves. Loeb took the project no further after Artaud's death on 4 March 1948, and it was abandoned.

Clayton Eshleman intended to translate *50 Drawings to assassinate magic* for this book, but ailing health prevented him from doing so prior to his death in 2021; as a result, I have translated it, directly from the manuscript notebook in which Artaud wrote it (notebook 396 of the notebooks from the last period of Artaud's life, numbered 1 to 406, and conserved at the Bibliothèque nationale de France in Paris). The notebook is pierced through from cover to cover with incisions from a knife, wielded by Artaud with great force, eleven times, leaving holes

which serve to indicate that the notebook was assaulted even before Artaud started writing in it, since he takes care to avoid writing in those incisions. Almost the entirety of the contents of that notebook is composed of the text *50 Drawings to assassinate magic*, with several fragments preceding and following it. The text has erratic punctuation, retained in the translation, and appears to stop dead in its tracks at several points; this version would not have been the text's final version if the planned book had gone ahead, and Artaud would certainly have reworked it and dictated the final version vocally, as he preferred to do. I am grateful for the support of the curator of Artaud's manuscripts at the Bibliothèque nationale de France, Guillaume Fau.

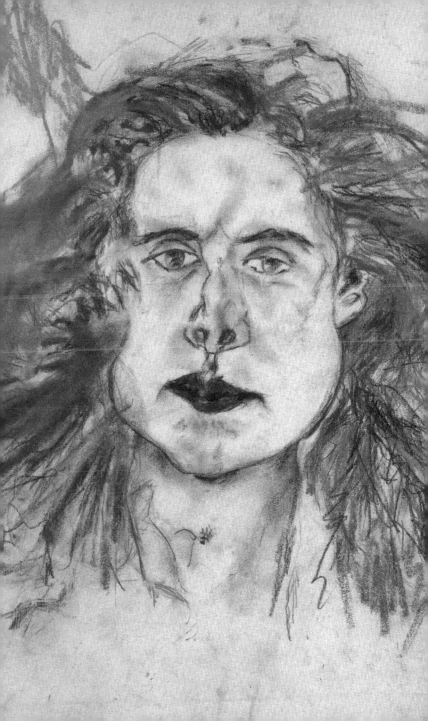

Contents

© DIAPHANES 2022
ISBN 978-3-0358-0248-1

DIAPHANES
Limmatstrasse 270 | CH-8005 Zurich
Dresdener Str. 118 | D-10999 Berlin
57 Rue de la Roquette | F-75011 Paris

Printed in Germany
Layout: 2edit, Zurich

www.diaphanes.net